CW00926303

S.Sarger

nt J.S

S.Sargent J.S.Sargent

nt J.S.Sargent J.S.Sar

S.Sargent J.S.Sargent

nt J.S.Sargent J.S.Sar

S.Sargent J.S.Sargent

nt J.S.Sargent J.S.Sar

S.Sargent J.S.Sargent

nt J.S.Sargent J.S.Sar

S.Sargent J.S.Sargent

nt J.S.Sargent J.S.Sar

J.S.Sargent J.S.Sargent J.
J.S.Sargent J.S.Sarg
J.S.Sargent J.S.Sargent J.
J.S.Sargent J.S.Sarg
J.S.Sargent J.S.Sargent J.
J.S.Sargent J.S.Sarg
J.S.Sargent J.S.Sargent J.
J.S.Sargent J.S.Sarg
J.S.Sargent J.S.Sargent J.
J.S.Sargent J.S.Sarg
J.S.Sargent J.S.Sargent J.
J.S.Sargent J.S.Sarg
J.S.Sargent J.S.Sargent J.

A SHORT BIOGRAPHY OF JOHN SINGER SARGENT

A SHORT BIOGRAPHY OF
John Singer Sargent

Carol Norcross

BENNA BOOKS
A Boutique Press for Artists & Writers
Carlisle, Massachusetts

A Short Biography of John Singer Sargent

Series Editor: Susan DeLand
Written by: Carol Norcross

To my mother
— C. N.

Copyright © 2017 Applewood Books, Inc.

978-1-944038-13-7

Front cover: John Singer Sargent (American, 1856–1925)
Self-Portrait, 1906, oil on canvas
Back cover: John Singer Sargent, *El Jaleo,* 1882
oil on canvas, Isabella Stewart Gardner Museum, Boston

Published by Benna Books
an imprint of Applewood Books
Carlisle, Massachusetts 01741

To request a free copy of our current catalog
featuring our best-selling books, write to:
Applewood Books
P.O. Box 27
Carlisle, MA 01741
Or visit us on the web at: www.awb.com

10 9 8 7 6 5 4 3 2
MANUFACTURED IN THE UNITED STATES OF AMERICA

JOHN SINGER SARGENT, one of America's most famous artists, was born abroad and actually never lived in the United States. His parents, Dr. Fitzwilliam Sargent (1820–1889) and Mary Newbold Singer (1826–1906), had been traveling in Europe for over a year to heal from the death of their firstborn in 1853, a two-year-old girl named Mary Newbold. Fitzwilliam was a successful eye surgeon at the Wills Eye Hospital in Philadelphia. Mary was an amateur watercolorist who had spent part of her childhood traveling in Europe. John was born on January 12,

1856, in Florence, Italy. With the birth of their second daughter, Emily, in Rome in 1857, Dr. Sargent understood that the family was not moving back to America and gave up his position at the hospital. They lived sometimes frugally, sometimes in style, in apartments or in boardinghouses. Summers were often spent in London or the Swiss or Italian Alps and cooler months in Rome, Florence, or Nice. The family seldom spent more than a month in any one locale. Two more children, Mary Winthrop and Fitzwilliam Winthrop, were born and died before Violet, their last child, was born in 1870. The children were raised with American values and European sensibilities; their strongest bonds were to family, and their closest friends were found in the expatriate community who shared their lifestyle. The continuous relocation due to his mother's restless nature and the deaths of John's siblings made him a continual outsider yet may have inspired his keen eye as an artist.

John loved to be outside and rebelled

against what little formal schooling he had. Due to the family's nomadic lifestyle he was usually homeschooled. He learned math, literature, geometry, and science from his father, who also instilled in the children a strong connection to America. His mother took the family to museums to study art and to gardens and palaces for history and architecture, always to sketch and draw. John spoke English, French, German, and Italian, and played piano and mandolin brilliantly. Tall and handsome, he was always shy and reserved, a good child and a good observer.

The family moved to Florence in the fall of 1873, and John attended classes for a few months at the Accademia di Belle Arti. John was gifted artistically and in May 1874, when he was eighteen, they traveled to Paris so that he could pursue a formal art education. The city, recovering from the Franco-Prussian War, was the center of the art world. The Impressionist painters exhibited for the first time that year, standing against the juried Salon

Dr. Sargent hoped that John would pursue a career in the U.S. Navy; his mother, Mary, wanted him to become an artist.

conducted by the Académie des Beaux-Arts. Artists identified their work with movements such as the Barbizon school, Naturalism, or Realism. Impressionism was one such movement. Sargent would see everything and be immersed in it all. He was young and interested in the artistic rebellion, but his lifetime of traveling and adapting gave him a more global view than most of the young Parisian renegades. He arrived at the atelier of Carolus-Duran with armloads of artwork to become a pupil. The other students—mostly Americans—were impressed with John's talent. Charles Auguste Emile Durand, known as Carolus-Duran, was a young, well-connected, and celebrated portrait painter who was a member of the conservative Académie des Beaux-Arts yet also friends with the rebellious Impressionists. To become successful, one had to have work accepted by the Salon. This powerful entity decided what artists were officially sanctioned, worthy of commissions, and had done so since 1648.

Sargent was well-dressed and polite and spoke fluent French, which set him apart from the other American students.

Duran's pupils studied Spanish artist Diego Velázquez and learned to paint *au premier coup* (at first stroke), also known as wet-on-wet painting. Oil paint was applied directly to the canvas or over still-wet paint with no reworking. Brushwork was key and a work could be created in a short time. While this technique had been used since the fifteenth century, in the 1870s it was considered a modern way to paint. Traditional artists of the time applied thin layers of paint that were allowed to dry before more layers were added. Brushwork was less important, and it took much longer to complete a work.

In 1834 American artist John G. Rand invented resealable tin tubes for oil paint. This made the paint portable and allowed it to last longer and be more versatile.

> *"It is certain that at certain times talent entirely overcomes thought or poetry."*

Sargent passed the competitive proficiency exams offered by the prestigious École des Beaux-Arts that fall, placing 37th out of 162, a substantial achievement since he had little formal art education.

Tuition was free and classes were more academic than Duran's, and included drawing, anatomy, ornament drawing, and life drawing in a set order. Proficiency exams were also required for a student to advance to the next level of instruction. The higher a student ranked in the exams, the greater the prestige for student and teacher. Sargent studied with Duran in the morning and at the École in the afternoon.

In 1876 America was celebrating the one hundredth anniversary of the signing of the Declaration of Independence. That year Sargent traveled with his mother and sister Emily to the United States for the first time. It was an exciting time to be with friends and relatives in Philadelphia and to be in the country that they called home. The city was hosting the Centennial International Exhibition, the U.S.'s first official World's Fair. Sargent was discovering this new country at a time when important inventions were being introduced that inspired the imaginations of scientists and artists alike. Returning to Paris,

Always the traveler, Sargent also visited Niagara Falls and Montreal before returning to Europe.

Sargent took the École proficiency exams for the third time in 1877 and placed second—the highest score for any of Duran's students and the highest yet achieved by an American. That May, John's painting of his childhood friend, Frances "Fanny" Sherburne Ridley Watts, was his first accepted by the Salon. The same year, Carolus-Duran was commissioned to create a mural called *Gloria Mariae Medici* for the ceiling at the Palais du Luxembourg, a former royal residence in Paris. Public art was considered "high art," the most exalted form of work an artist could do. John jumped at the opportunity to help Duran and each added a portrait of the other into the design. Sargent's growing reputation crossed the ocean, and he was asked to be a juryman in Paris for the new Society of American Artists in New York. They wanted to showcase modern art, especially the sophisticated work being done in Europe. There were enough American artists working abroad for their art to be juried in Paris before being sent to a New York

exhibition. This meant that Sargent now had connections to the most progressive American artists of the day. Unlike most of the Impressionist artists, young Sargent was attracting widespread success. Sargent was twenty-one years old.

Steamships had recently made intercontinental travel much faster, and because of this, Sargent could take advantage of the international art market.

Because the Salon in Paris was so important, artists often produced work specifically for it. The exhibition was displayed at the Louvre, with works completely covering the walls. Here, a large dramatic painting would stand out. Sargent began to travel to far-flung locales specifically to find inspiration for his Salon entries, and in the summer of 1877 he went to the coast of Brittany to do studies of oyster gatherers. Two versions were completed: A smaller canvas with looser brushwork was shown in New York, while the larger, more academic version was exhibited at the Salon in 1878. Both versions received acclaim.

Sargent submitted two works to the Salon in 1879. One was a portrait of Carolus-Duran, for which Sargent was

awarded honorable mention. This accolade meant that his work would be accepted automatically for the next Salon. In the work Duran is relaxed yet elegant, and looks directly at the viewer. One spot of color—a red rosette—signifies that he was *chevalier* of the *Légion d'honneur* for his artistic achievements. The subdued colors, the brushstrokes, all pay tribute to Velázquez —and to Duran. It is no surprise that Sargent was seen by some as outdoing his teacher. He began receiving more commissions, and it secured his career in portraiture.

Paris was enamored of everything exotic—and that inspired Sargent to travel to countries that fed the Parisian obsession. In late summer of 1879, Sargent began a long trip south through Spain and then nine hundred miles across North Africa from Tangier to Tunis.

> *"Above all things, get abroad, see the sunlight and everything that is to be seen."*

France has awarded knighthoods, *chevaliers,* for military and artistic achievements since 1802.

Sargent studied Velázquez at the Prado, painted or sketched every day, and in the evenings would go to cafés that featured music and dance. Sargent had a profound love of music and was electrified by flamenco. It was a fusion of cultures found in Andalusia and was spread throughout Spain by the *gitano,* the Romani people of Spain. *Jaleo de Jerez* is danced by a woman to the strains of a poignant lament. Moments of exquisite footwork, vocalization, or musicality are encouraged with *jaleos*— shouts of *"olé!"* Sargent learned of Romani culture through the musicians and dancers he met. The studies he did would form the foundation for one of his most famous and dramatic works: *El Jaleo.*

Sargent often told people that he considered himself half-Gypsy.

While in Morocco, Sargent started work on *Fumée d'ambre gris,* which would become one of his two Salon entries that May. He brought the unfinished canvas—a white-on-white study of a woman with her head scarf held open to receive the perfumed smoke of an incense burner—back to Paris. The painting is myste-

rious and has the quality of a watercolor in its delicate tonality. Sargent's paintings are infused with drama, whether still life or portrait. His use of shades of white sparked and accentuated focal points, drawing the eye and controlling the view. *Fumée* and a commissioned portrait of Madame Edouard Pailleron shown in a very modern pose —standing in a flowery lawn—were well received by the critics.

When Sargent completed an important painting, especially a commissioned portrait, it would often be exhibited at several venues, say, Paris, London, New York, or Boston. If it was more radical in technique, it would be shown at a gallery or at one of the many non-Salon exhibitions in Paris. Critics on both continents would write about the work. To hire Sargent was to show one's avant-garde taste while advancing one's social status. The whole city could weigh in on how this elite artist had portrayed one's personality or virtues. He painted what he saw—for better or for worse.

The Pailleron family was one of Sargent's earliest supporters and commissioned twelve portraits from him.

In early 1881 Sargent traveled to Venice, and his stunning paintings and watercolors showcased its water, architecture, and light. He also depicted Venetian glass workers in factories, and the narrow streets of the city, sometimes empty, sometimes with shadowy figures—studies that used subdued tonality reminiscent of his Morocco works. The Curtis family, distantly related to Sargent, was at the center of the English and American expatriate community there, and that same year they moved into the fifteenth-century Palazzo Barbaro on the Grand Canal. Sargent would return often to visit. Back in Paris, one of four works he submitted to the Salon was awarded a second class medal. At twenty-five years old, he was now eligible only for the gold medal at future Salons.

That fall, Sargent started work on a massive canvas for his 1882 Salon entry. He wanted to portray the excitement of flamenco as he had experienced it and would call the painting *El Jaleo: The Dance of the Gypsies*. In it, candles at

Henry James would write about the Palazzo Barbaro ballroom in *The Wings of the Dove.* Henri Matisse, James Whistler, Edith Wharton, and many others visited over the years.

the edge of the stage dramatically illumi-
nate dancer and musicians. The dancer
is placed off center and, with her white
skirt intentionally blurred, seems to be
moving across the stage. This is a paint-
ing whose motion is felt intensely. The
painting was a huge success at the Salon
and he was the most talked-about artist
in Paris.

And then—scandal. Sargent used his
connections to convince Madame Pierre
Gautreau to pose for him. She had re-
fused all similar requests from artists prior
to Sargent. Born Virginie Avegno, she was
an American beauty and socialite who was
raised in Paris and married a banker. Sar-
gent worked over the summer to capture
her beauty. In the life-sized painting she
looks to her left, her profile bright against
the dark taupe background. A black heart-
shaped bodice accentuates her figure,
and one jeweled strap has slipped off of
her right shoulder. There is nothing else
in the room besides a table. The painting
was called *Portrait de Mme* *** when it

Madame
Gautreau
used violet-
colored face
and body
powder to
highlight her
features.

was exhibited at the 1884 Salon, but everyone knew who was depicted. Critical response was swift and ruthless: the fallen dress strap was shocking, the pose far too erotic. Her skin tone was compared to that of a corpse. While Sargent had created bold work before, this time traditionalists felt he had gone too far. Madame Gautreau had believed that this was a masterpiece; now she was in tears, and her mother demanded that the portrait be withdrawn from the Salon. Sargent would rename the painting *Portrait of Madame X* years later, hoping to make it seem mysterious and impersonal, drawing the attention away from the Gautreaus. Sargent called it "the Gautreau disaster" and his portrait commissions dried up in France. The painting hung in his studios for the next twenty years.

Sargent repainted *Portrait of Madame X*'s dress strap after the Salon so that it was properly positioned.

Throughout his life, Sargent spent time traveling with his family, fellow artists, writers, and childhood friends. His family had continued their nomadic lifestyle and never returned to America. Even while

vacationing, he maintained a strict work schedule: breakfast at seven, start painting or drawing at eight, take a lunch, back to work until five. He painted whatever he wanted—architectural studies, watercolors, paintings of his companions. The artists were often portrayed at an easel, engaged in what he himself was doing. In the evenings, everyone would play music or chess before going to bed early. With these people he was most at ease, known for his satiric wit and spot-on impersonations of people. Outside of this circle, he was often seen as dull, reserved, and very private.

Sargent's sister Emily was a year younger than he was. She permanently injured her spine when she was four, and the two were lifelong friends and traveling companions.

> *"You can't do sketches enough.*
> *Sketch everything and keep your*
> *curiosity fresh."*

After the debacle of *Madame X,* with Paris society in shock and no commissions on the horizon, Sargent began painting with his friend Claude Monet in Giverny, France. The American author

Henry James became profoundly interested in Sargent's career and encouraged him to move to London. James, who also had an expatriate childhood, introduced him to his wide circle of artists and authors. Sargent and James would remain lifelong friends. Sargent began to paint with artists in the Cotswolds and reconnected with Oscar Wilde and Robert Louis Stevenson in London. Stevenson posed for him several times. After the disaster in Paris, only friends would allow their portraits to be done. Sargent began experimenting more with Impressionism and other styles and turned again to landscape, sometimes re-interpreting a Monet painting in his own style. In 1886 he moved permanently to London, and in 1887 his painting of two young girls lighting Chinese lanterns, *Carnation, Lily, Lily, Rose,* was purchased for the British national collection. He had worked on it over two summers, painting for only ten minutes at a time when the fading light was perfect. But at this time, even though he was elected a full fellow

Robert Louis Stevenson had known Sargent for years and sat for him between publication of *Treasure Island* and *The Strange Case of Dr. Jekyll and Mr. Hyde.*

of the Royal Academy of Arts, London, Sargent's work was seen by the British as too French, not appropriate for English taste. Sargent, at thirty-one years old, was not getting commissions.

Henry Marquand, a well-connected American financier and collector, invited Sargent to the United States in the fall of 1887. This was the introduction to wealthy Americans that Sargent desperately needed. Henry James wrote an article for influential *Harper's* magazine about Sargent. Architects Charles McKim and Stanford White suggested his name to their clients, and Sargent suddenly had commissions in Boston, Newport, and New York. Here was an American artist with a daring, innovative style. Sargent's first one-man show was in Boston during this trip. It included new portraits along with earlier work and was an immense New World success.

Sargent remained involved in the art scene in Paris as he continued to work elsewhere. He and Claude Monet raised

Americans embraced the French Impressionists' work and bought their paintings long before the radical artists had success in Europe.

funds for Édouard Manet's *Olympia* to be acquired by France, donating his own money to this cause. Despite being vilified by Paris society in 1884, his reputation had been sufficiently restored, and Sargent was named *chevalier* of the Légion d'honneur and chosen to be on the Salon jury. By the time he returned to America with his sister Violet at the end of 1889, everyone who was anyone needed a Sargent. He painted over forty portraits in nine months, exhibiting many of them. His recent paintings of actors, sometimes in their stage roles (Ellen Terry, Edwin Booth) gave new inspiration to his portrait work. Lighting became more theatrical, backgrounds more spare. As his portraits were exhibited in America and London demand grew exponentially; when Sargent didn't have time to come to the U.S., people would travel to him in London. Photos of his studio from this time show props that can be seen in some of the portraits.

A portrait sometimes required only a

For *Mrs. Davis and Her Son Livingston Davis,* Sargent positioned the two just inside their horse stable, daylight highlighting them against an undefined background.

few sittings—each lasting several hours—or might require over eighty sessions when dealing with uncooperative children. The easel would be placed next to the sitter so that Sargent could see both from across a room. Deciding on his course of action, he would head quickly and directly to the painting to add a few brushstrokes. Then Sargent might rush to the piano and play a few phrases before painting again. The sitter's features seemed to emerge out of the light and dark planes of paint organically. The face was more modeled, while the rest of the figure or other objects in the room might be created with a few brilliant strokes of paint that pulled together as one stepped away from the painting. Suddenly those slashes of color became a dog, a dress, or a table. This also brought attention to and highlighted the figure's face. If the effect was not right, Sargent would scrape off the paint and start again. Sargent studied Frans Hals and Velázquez throughout his life to perfect this sense of the dramatic.

Sargent would provide, or have clothing made to order for a painting. He might even decide what kind of stockings—cotton or silk—were worn.

Boston increasingly became important to Sargent's career. Isabella Stewart Gardner, a Bostonian by marriage, and Henry James had visited Sargent in Paris to see the infamous portrait *Madame X* in 1886. Sargent painted Isabella's portrait two years later and she became a friend and an important supporter of his work. Because Sargent knew how much Gardner loved *El Jaleo,* he recreated it as a dance recital with Carmencita, an internationally known Spanish dancer, in Gardner's New York City apartment. The Curtis family's Palazzo Barbaro inspired the design of her Boston home, which she opened as the Isabella Stewart Gardner Museum in 1903. There, *El Jaleo* was showcased in the Spanish Cloister gallery designed specifically for this painting. When Sargent was in town, he would use the Gothic Room as a studio, and his portrait of Gardner has always been displayed there.

In 1890, Charles McKim and Stanford White suggested that Sargent create a

Isabella Stewart Gardner's husband did not allow Sargent's portrait of her to be shown publicly after he overheard lewd comments about the décolletage of her dress.

series of murals for their Boston Public Library project. For Sargent, this, like Duran's ceiling commission, represented the greatest achievement of an artist. He decided on *Triumph of Religion* as the theme for the hall and headed to Egypt and the Middle East for inspiration with his mother and sisters. Sargent understood that his painting style would not work for the murals—his exquisite brushstrokes and detail work would be lost when seen at a distance. This recognition inspired John to alter his technique to accommodate the conditions of distance and perspective. Paintings were done in his London studio, then transported to Boston. He added innovative details to the canvases such as plaster and papier-mâché to suggest bas-relief sculpture and designed decorative elements to unify the room itself. Shortly after the library opened in 1895 the first murals were unveiled. Sargent would work on this and other mural projects for the next thirty years.

In 1902 Sargent charged 1200 guineas for a painting, equivalent today to about $180,000.

Sargent never had a painting assistant and never taught. He kept his own books, sometimes to the dismay of his clients, and arranged his own travel and appointments. Demand continued for his work even though he kept raising the price. His mother died in 1906 while he was doing research in the Holy Land—Syria and Palestine—and he rushed back for memorial services. Now that he was financially secure he began to refuse most portrait commissions. If you were a Rockefeller or a friend, he might acquiesce, but he spent time traveling and working on the mural commission, watercolors, and landscapes.

The Boston Public Library murals were installed in four separate groups over twenty-four years. They were so popular that funds to continue the project could be raised from the public in a few weeks. Sargent's inspiration came from many sources, including medieval sculpture, Byzantine mosaics, and Persian architecture. The murals are lavish in their intricate design and gold details. Sargent, as

Reproductions of *Frieze of Prophets* were sold across America shortly after the murals were installed.

did others in his time, believed that religious institutions would fade away and a person's own belief system would become central. A library itself was sacred as a temple of learning. The murals were to reflect these beliefs, showing the rise of paganism and organized religion and then the decline of those same institutions as spirituality became internalized. But in 1919 when *Synagogue and Church* were unveiled, some felt that he was showing the superiority of Christianity over Judaism and lobbied for the removal of *Synagogue.* Sargent was upset by the controversy and never completed the last panel, *Sermon on the Mount,* which was to represent the spirituality within one's own heart.

World War I erupted before Sargent completed the library murals. His optimistic hopes for the betterment of humankind were replaced by the horror of what man could accomplish. His dearest niece, Rose-Marie Ormond, lost her husband shortly after he enlisted. She was

Violet was the only sibling to marry. Her daughter, Rose-Marie, is often called Sargent's muse because of the many paintings he did of her.

killed in 1918 when a bomb hit the Parisian church where she was attending a concert. This affected Sargent greatly. When sent to the front by the British government to document the war, he created *Gassed,* a monolithic painting about the effects of mustard gas on soldiers. He also completed two murals memorializing the many Harvard University students and faculty who had died during the war.

Sargent had started murals for the Museum of Fine Arts, Boston's new building before the controversy over the *Synagogue* mural at the library had begun. Here, he chose to portray allegorical themes from classical antiquity to match the neoclassical architecture. This also echoed the main thrust of their collections at the time—plaster copies of famous Greek and Roman statues. The MFA's murals are very different from any of his previous work, including the library murals. While many of the sections are painted on canvas, some are plaster bas-relief. Most have a limited tonal range similar

to Wedgwood jasperware. Sargent requested—and received—major changes to the building's architecture so that his artistic vision could be realized. In 1925 Sargent packed up the last of the murals, ready to sail to Boston for the final installation. He died in his sleep the night before his ship sailed; he was sixty-nine years old.

Sargent never married; his sister Emily was his most faithful companion. Intensely private and reserved his whole life, there is no evidence to suggest that rumored affairs with women actually existed. He remained a mystery even to his friends. The artist Paul Helleu, a painter who had known him for many years, tried to investigate his sexuality and came up with nothing. Married couples, single men and women, artists and authors, gay and straight, all were his friends. But if Sargent had been openly gay, it would have meant an end to his career. Oscar Wilde was imprisoned in England in 1895 for "the love that dare

Sargent also helped the fledgling MFA Boston acquire art—including an El Greco painting from Spain.

not speak its name," and openly gay men fled the country. In his work Sargent stretched the boundaries of what was considered proper behavior. Even his relative, Mrs. Curtis, famously refused a gorgeous painting because she felt that her son was depicted ambiguously. Many of the watercolors done in the Alps would had been viewed as unseemly at the time—girls' ankles and legs showing, men lounging in the grass, bodies sometimes intertwined. Explicit male nude charcoals that he drew were never exhibited during his lifetime.

Sargent is buried in Surrey, England. He shares a grave marker with his sister Emily, and next to it is an identical marker for his sister Violet and her husband, Louis Ormond. Sargent's marker is inscribed with the words *Laborare est Orare*—to work is to pray.

During much of the last century, Sargent has been dismissed as simply a society painter and as an artist whose work is the end of a tradition, rather than a

beginning. In his own lifetime he was able to keep his art relevant, receiving accolades and awards throughout his career. King Edward VII wanted Sargent to paint his coronation portrait, but Sargent felt that a British artist should do it. To the British he was a Brit—King Edward VII wanted to bestow knighthood on Sargent, but he politely refused because it would be unpatriotic for him, as an American, to accept. To the Americans he was a native son, and the largest collections of his art are in its museums. The murals at the Boston Public Library and MFA, Boston have been recently restored.

Sargent's work remains powerful When Sargent sold *Madame X* to the Metropolitan Museum of Art he wrote, "I suppose it is the best thing I have done." This work could finally be displayed and not reviled. In Sargent's paintings and watercolors there is always the light that cannot be dismissed. It glints off Venetian gondolas, bubbles up from streams,

and dapples sunlit faces. Sargent and his work remain mysterious, and perhaps because of that, Sargent has found new relevance today.